Best of
BAR HARBOR

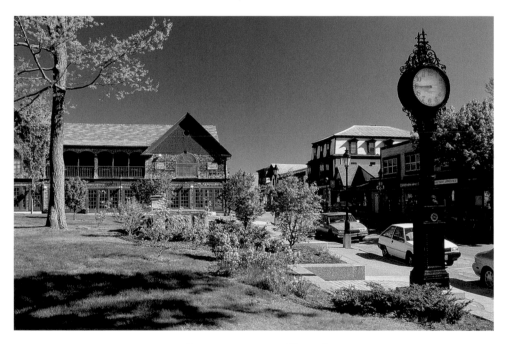

Greg Hartford

ISBN: 978-0-89272-794-0

5 4 3 2 1

Cover and text design by Lynda Chilton
Printed in China

Down East
BOOKS·MAGAZINE·ONLINE
www.downeast.com
Distributed to the trade by National Book Network

Library of Congress Cataloging in Publication
information available by request

For more information on the Acadia region, and to
see more of Greg's photographs, visit his Web site:
www.acadiamagic.com

Dedicated to my grandparents, Don &
Erma, who first showed me the beauty of
the Bar Harbor area; and to my late dear
friend, George, my adopted brother,
James, and my mother, who has loved
me all of my life.

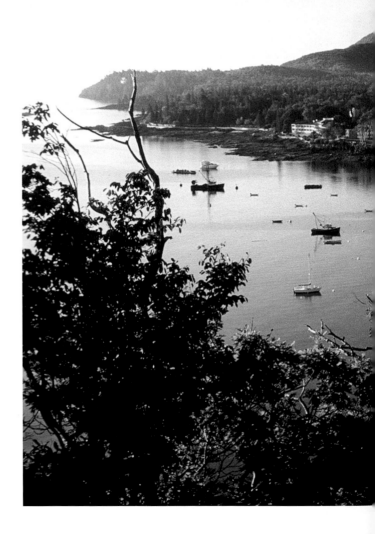

Normally quite busy in late summer, Bar Harbor
seems tranquil when observed in the early morning
from Bar Island.

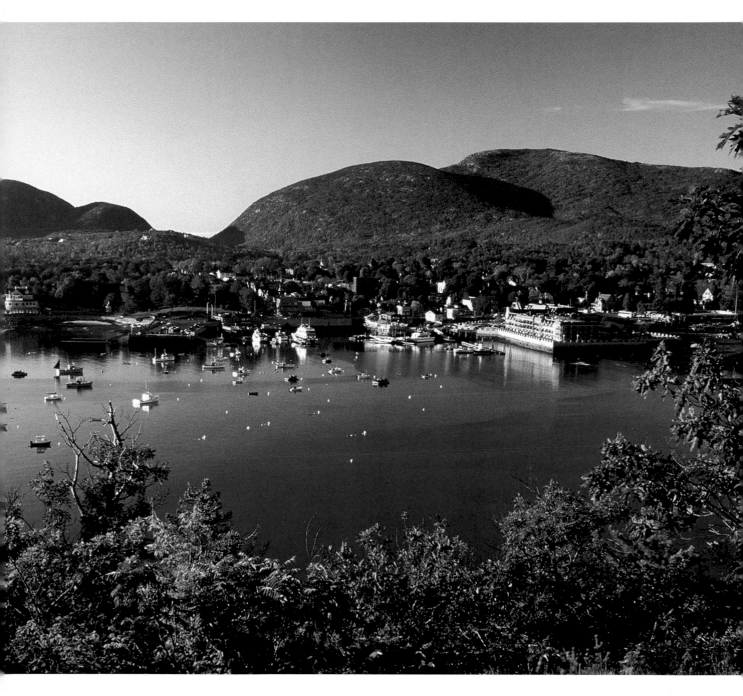

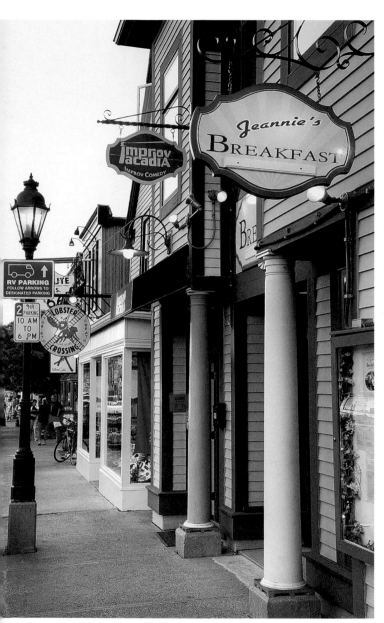

Bar Harbor is a shopper's paradise. At these shops on Cottage and Main Streets, visitors can collect a wide array of gifts and keepsakes.

4

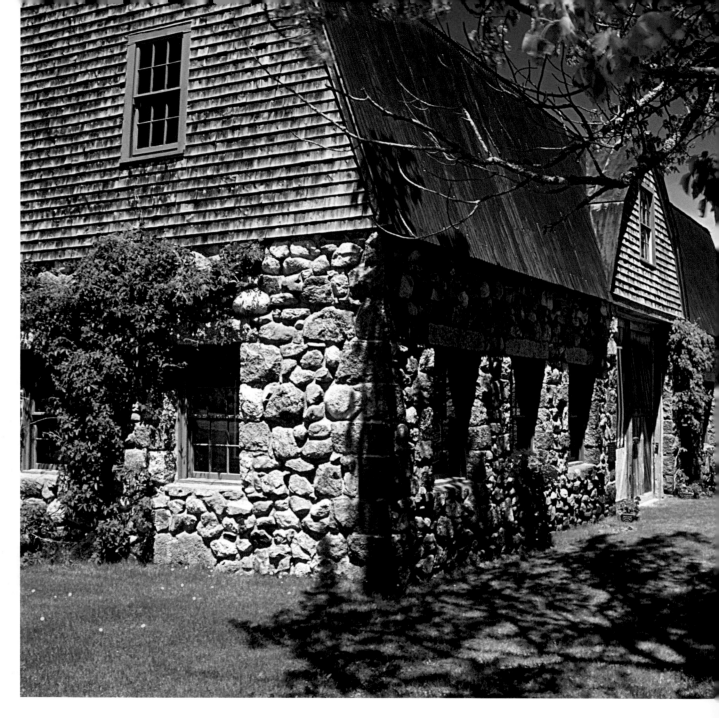

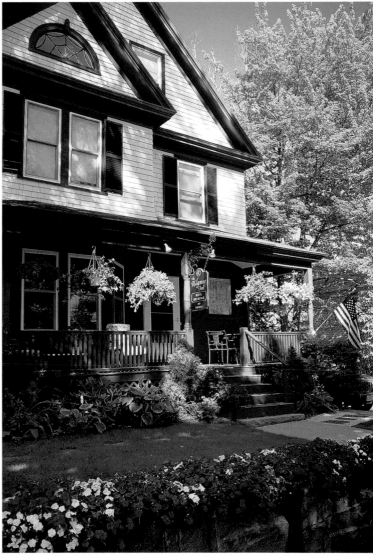

Left: Stone Barn Farm, near Town Hill, is a national historic site, and its 128 acres of fields, forests, and fens are protected by a conservation easement with the Maine Coast Heritage Trust. **Above:** The summer porch of the hundred-year-old Victorian Ridgeway Inn is an inviting place to enjoy an afternoon.

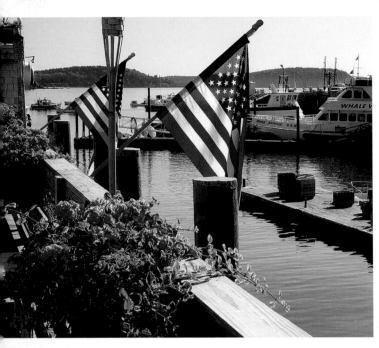

Above: A quiet morning on the waterfront off West Street.
Right: Enjoyed primarily by summer residents, beautiful Northeast Harbor is located at the entrance to Somes Sound, the only fiord on the east coast of the United States.

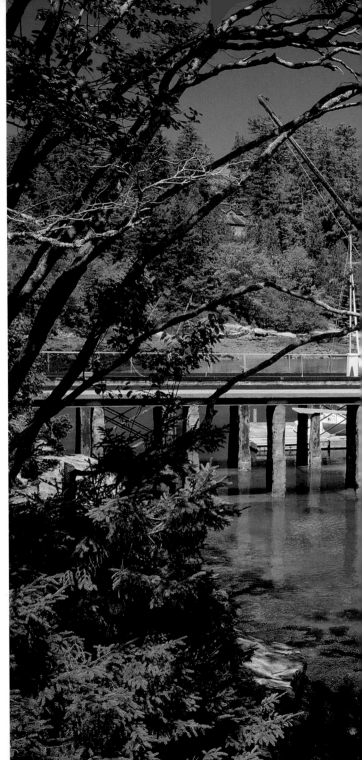

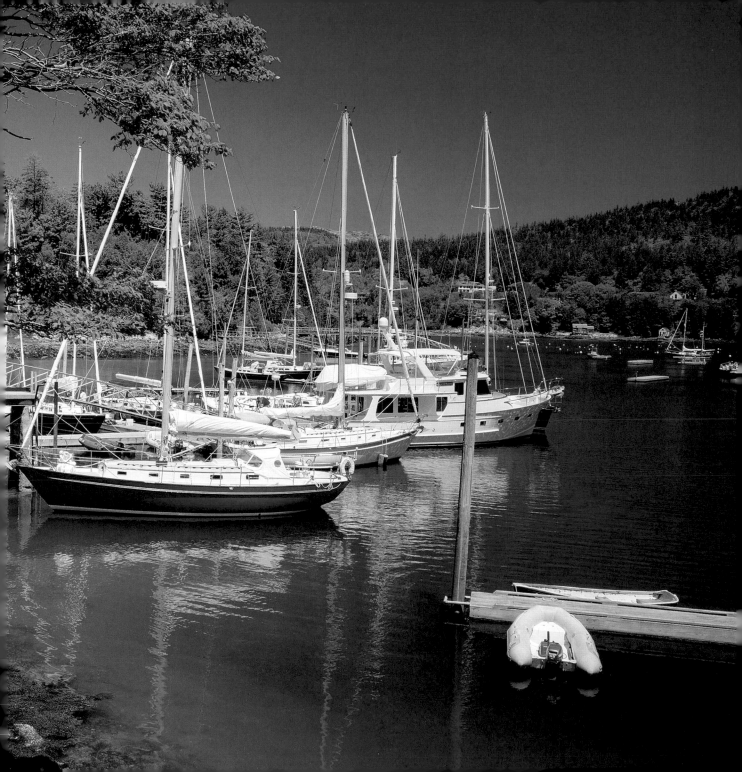

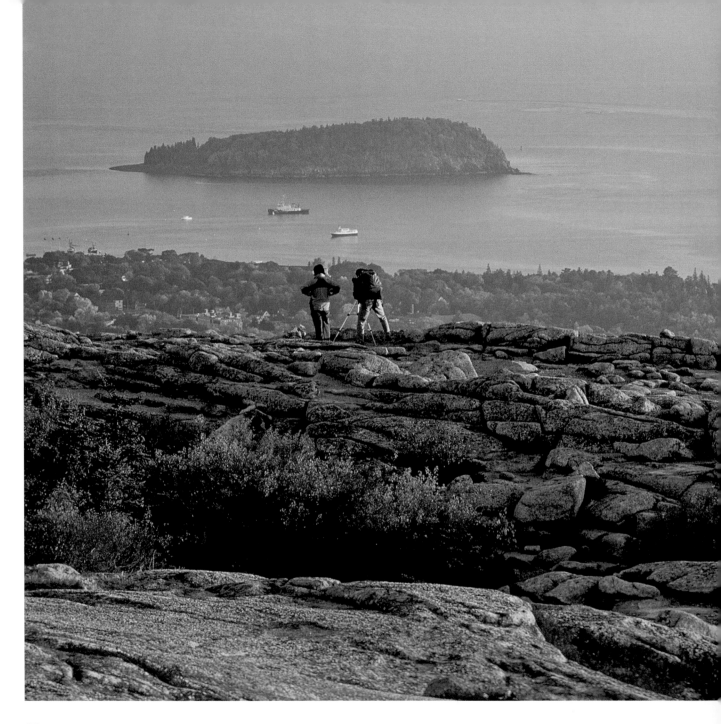

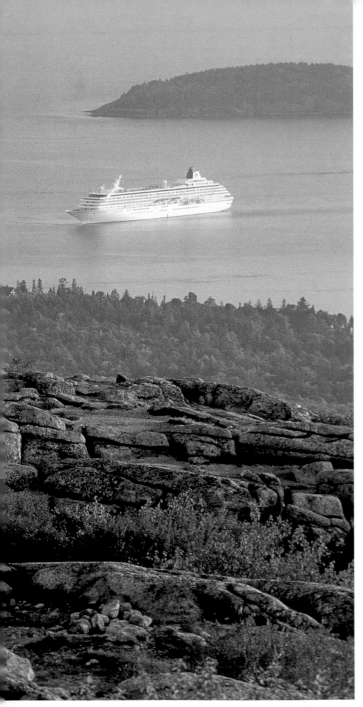

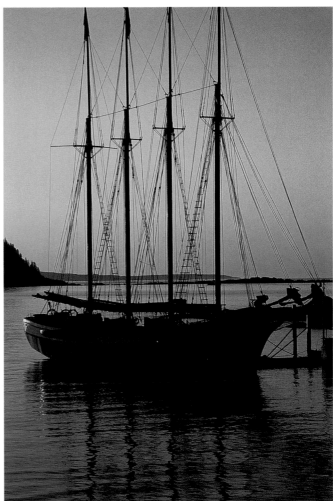

Left: At 1,532 feet, Cadillac Mountain in Acadia National Park is the highest point along the North Atlantic seaboard, and, between October and March, it is the first place in the United States touched by the rays of the rising sun. It also provides excellent views of Bar Harbor—and of the cruise ships that visit in the summer and early fall. **Above:** All quiet aboard the four-masted schooner *Margaret Todd*.

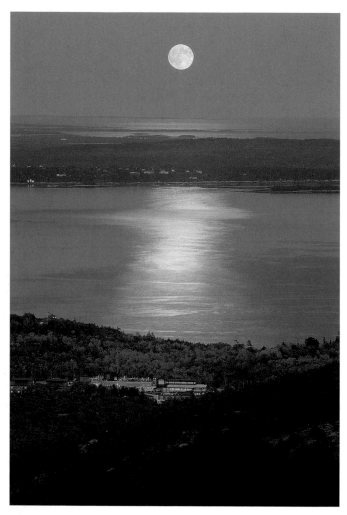

Above: Moonrise over The Jackson Laboratory, one of the world's leading genetics research facilities. **Right:** Started as a social club in 1847, the Bar Harbor Inn & Spa is today the town's most prominent hotel, and one of Maine's finest oceanfront properties.

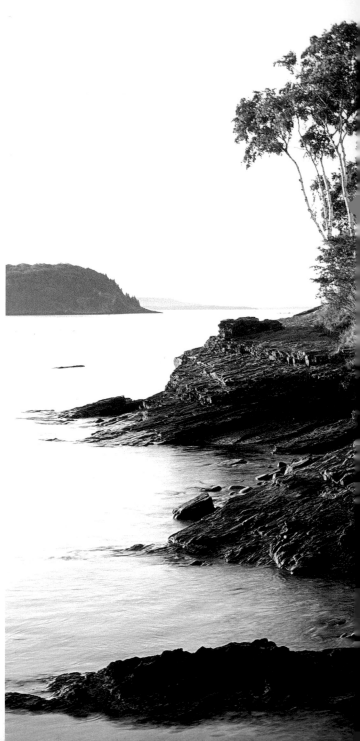

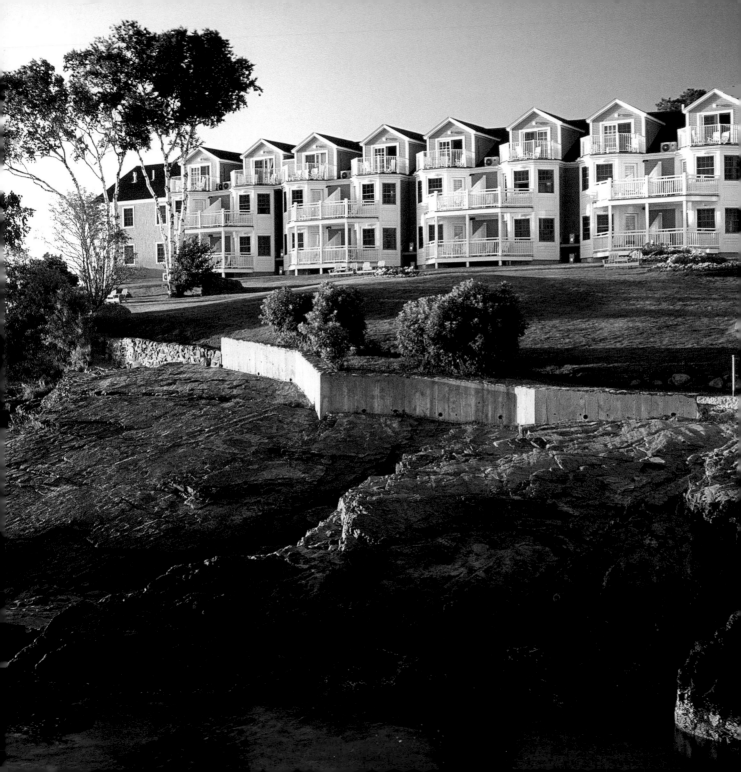

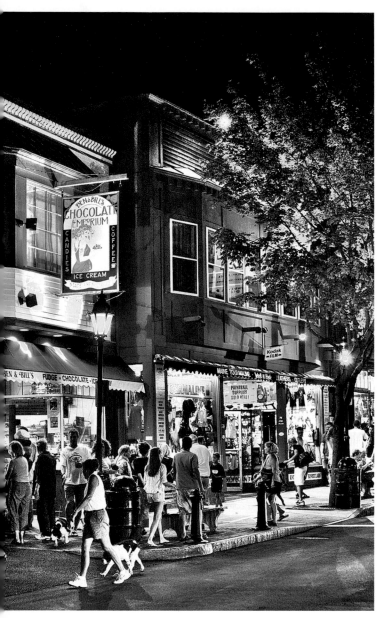

In the summer Bar Harbor is a bustling place, and this activity often carries over into the evening.

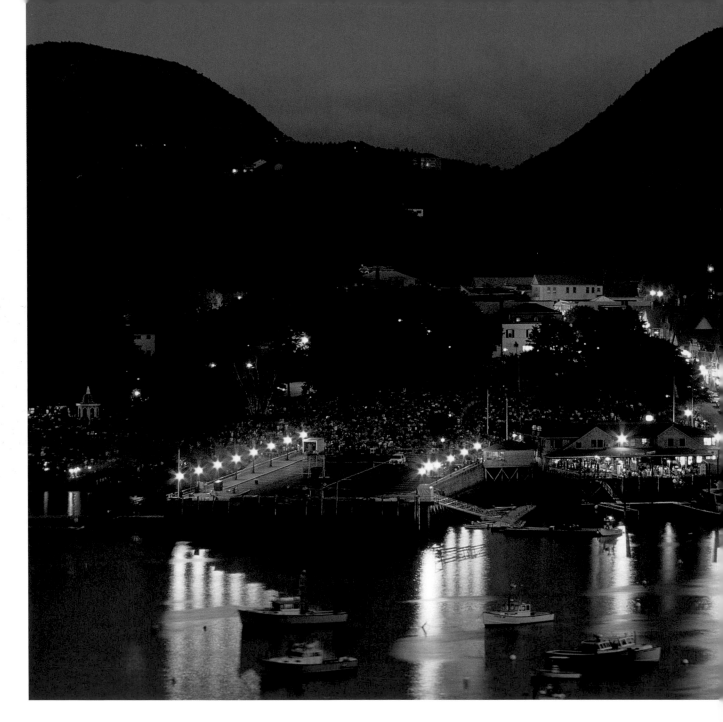

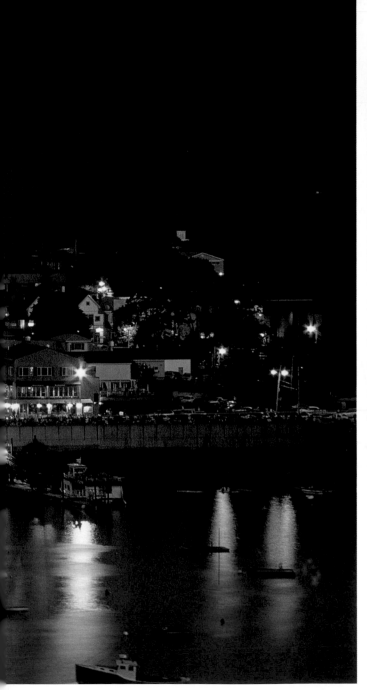

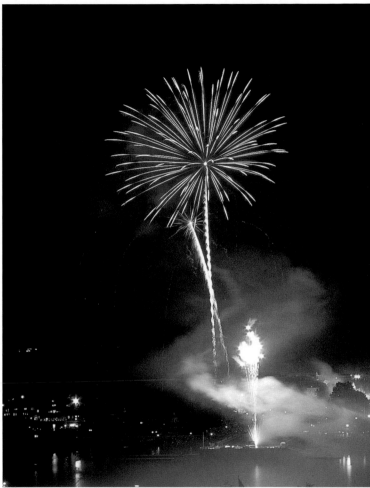

Fourth of July at Bar Harbor: the waterfront teems with spectators awaiting the fireworks.

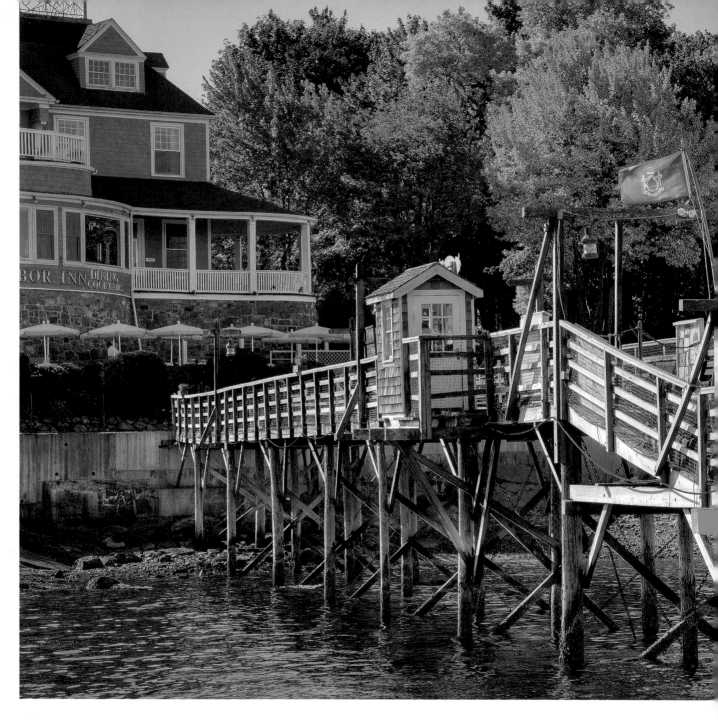

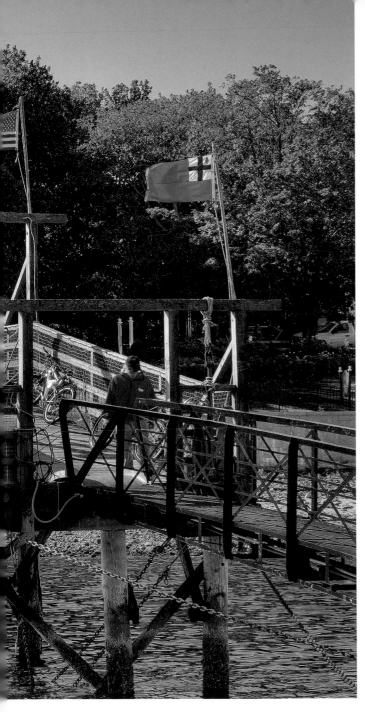

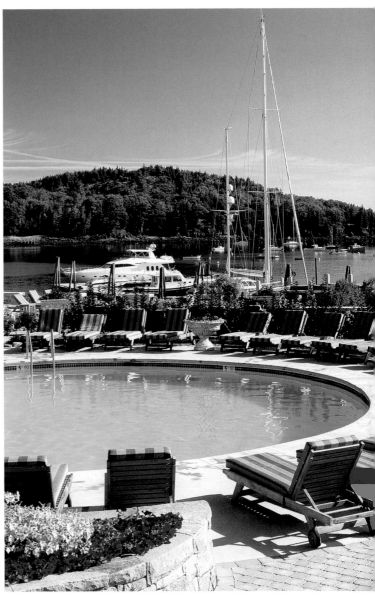

Left: Traffic on the Bar Harbor Inn pier is noticeably diminished on blustery fall days. **Above:** The Harborside Hotel, Spa & Marina is the premier resort facility in Bar Harbor, especially for those guests who arrive in their own boat.

Salisbury Cove is a quiet and lovely little village on the north side of Mount Desert Island. **Above:** The Eden Baptist Church. **Right:** Summer porch, private residence.

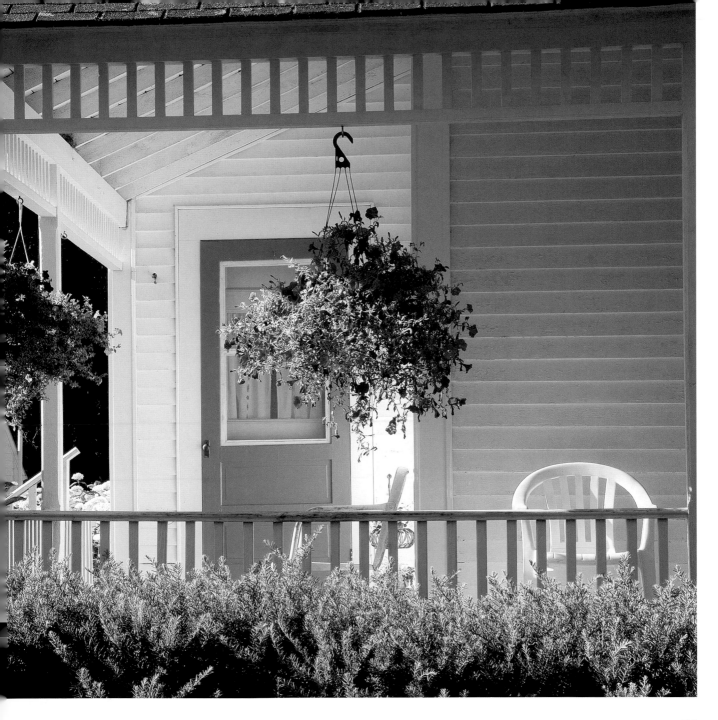

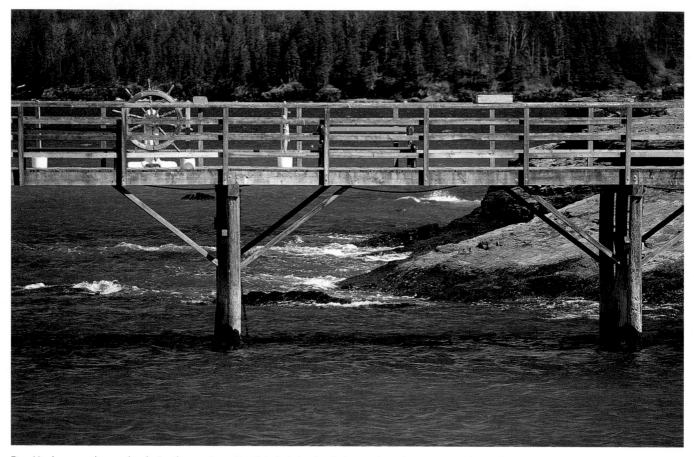

Bar Harbor awakens slowly in the spring. On this bright April day, a lone bagpiper is the only person to greet the sea.

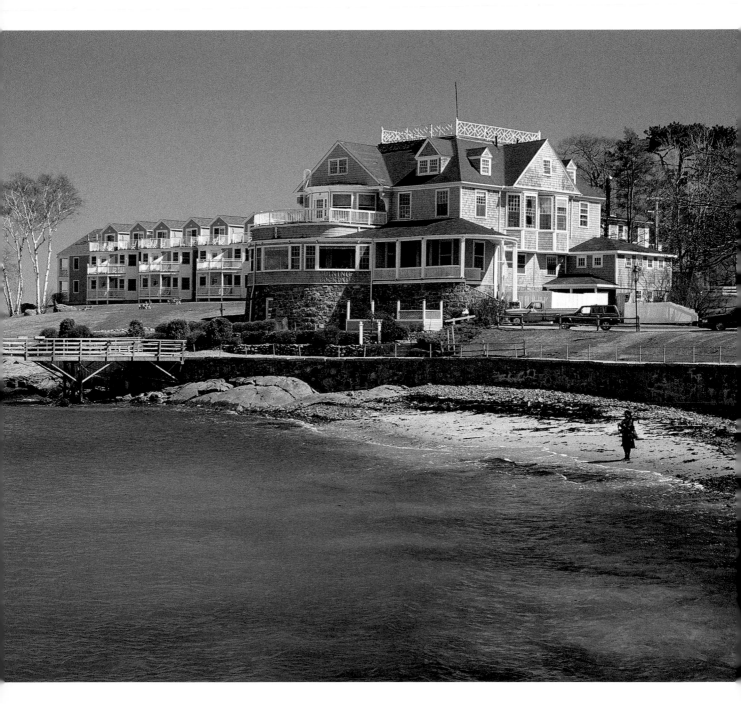

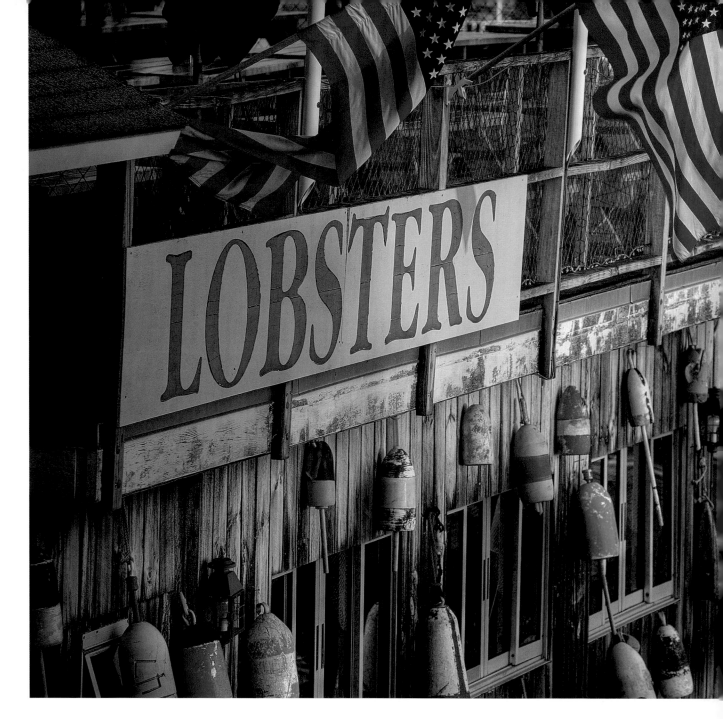

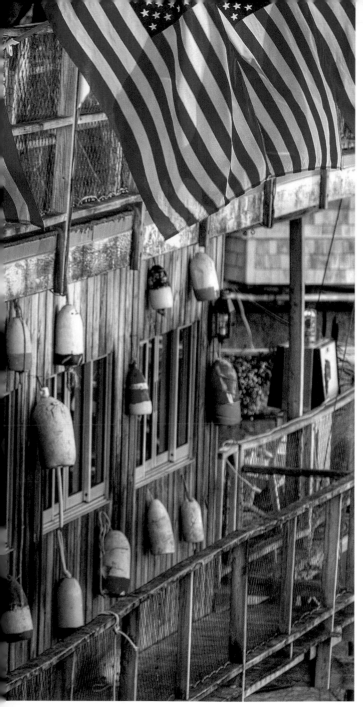

Stewman's Lobster Pound serves up Maine's favorite sea-
food. And it's right on the wharf, so diners can enjoy terrific
views of the harbor.

Autumn may be the best time to visit Bar Harbor. The pace has begun to slow down as summer visitors depart, yet most businesses remain open. **Above:** Main Street. **Right:** Mount Desert Street.

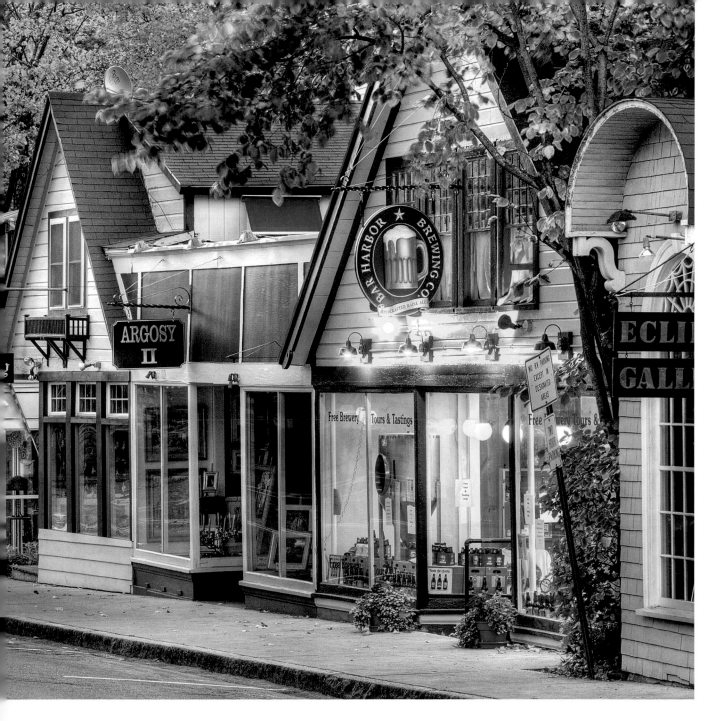

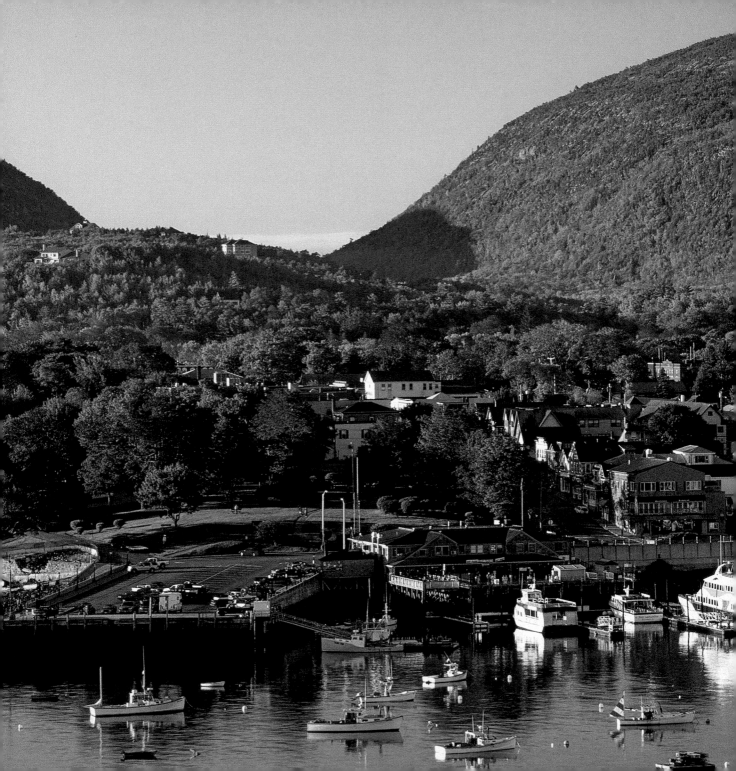

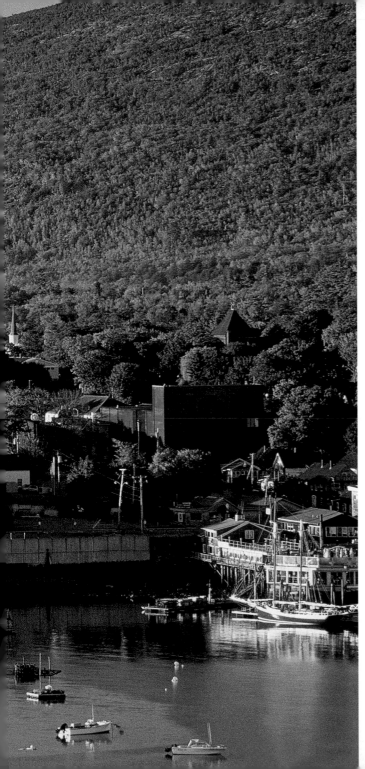

Fall brings cooler days and stunning foliage, which can be especially appreciated on the hiking trails of Acadia National Park.

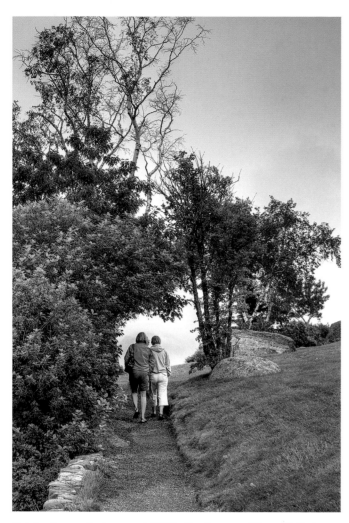

Originally created around 1880, the famous Shore Path begins at the town pier and continues south along the eastern shore of Mount Desert Island. People have walked this path ever since. Offshore to the east are the four Porcupine Islands, which are especially beautiful at sunrise.

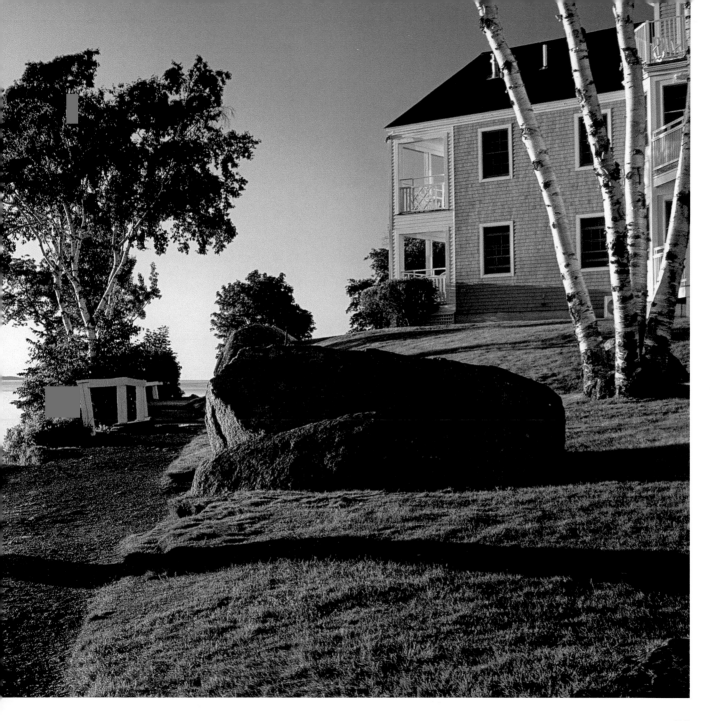

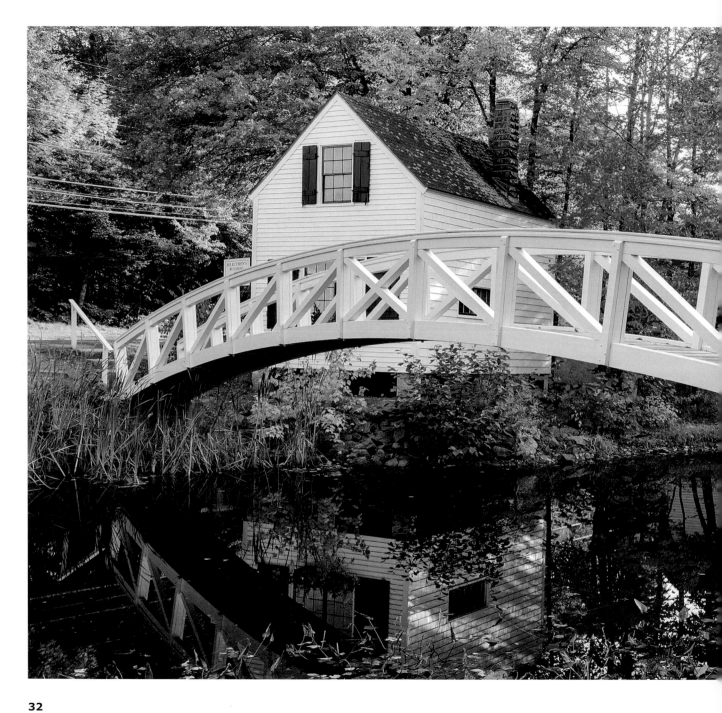

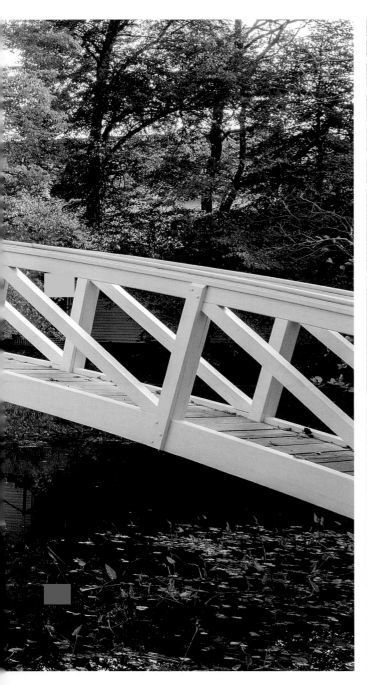

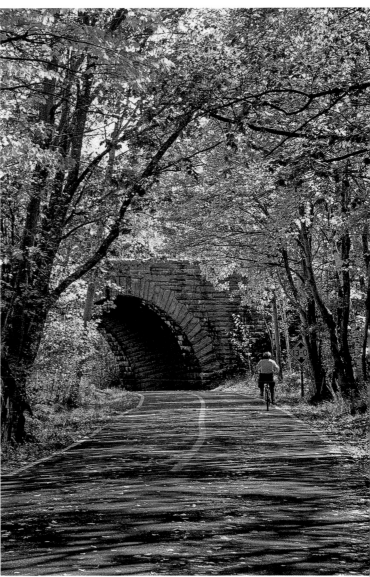

Left: Dating from 1761, picturesque Somesville is the oldest settlement, and its footbridge is arguably the most photographed location, on Mount Desert Island. **Above:** The New Eagle Lake Road runs along Duck Brook and passes beneath a stone bridge and one of Acadia's famed carriage roads.

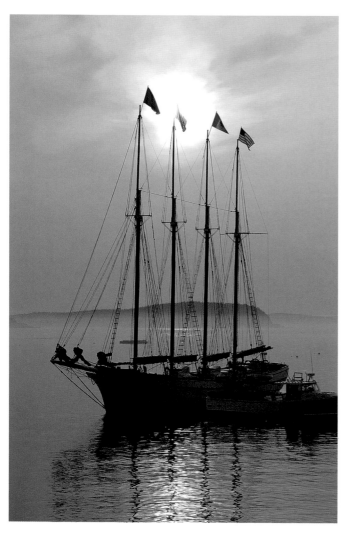

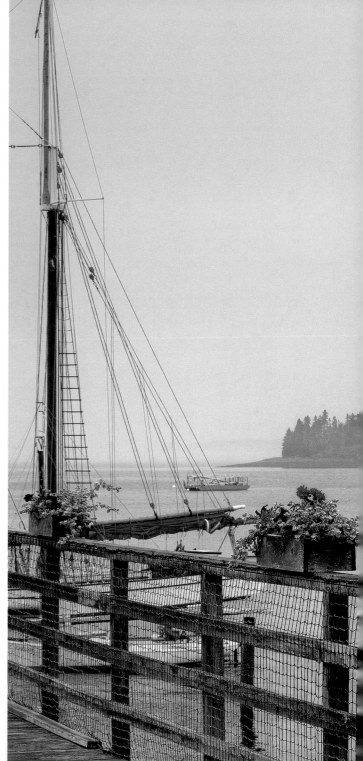

Above: The *Margaret Todd* takes passengers on daily sail cruises (weather permitting) in the morning, afternoon, and at sunset. **Right:** Though more well known for its visitor accommodations, Bar Harbor is still very much a working community, as these scallop draggers attest.

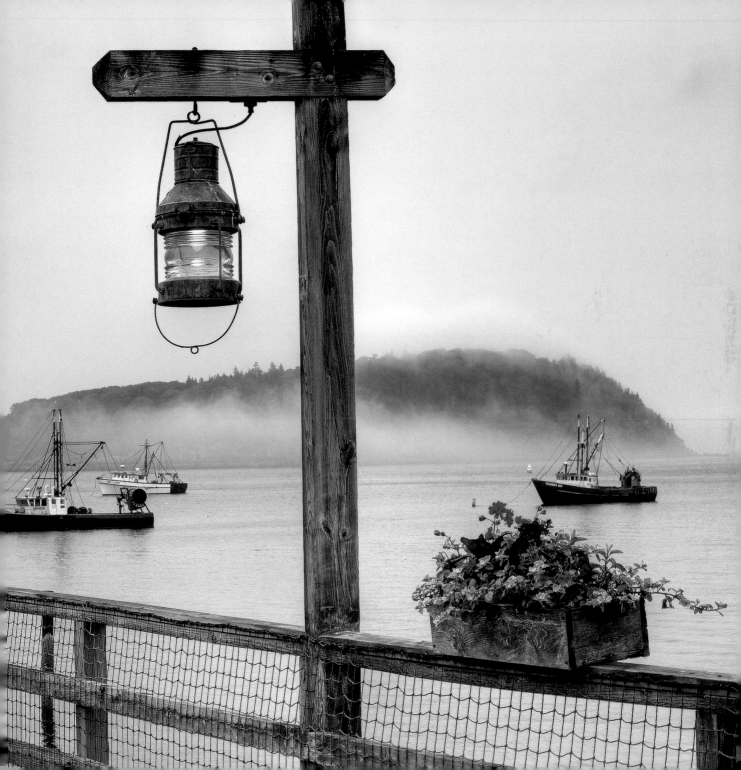

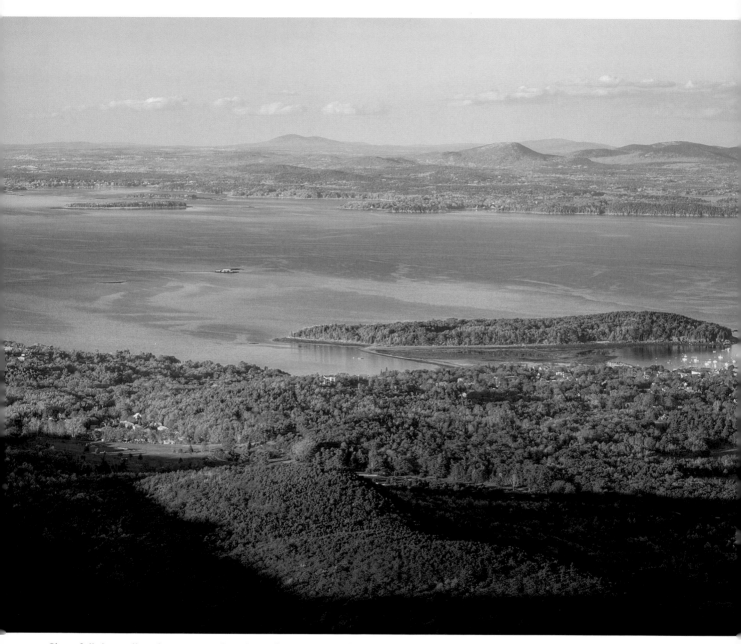

Clear fall days allow for spectacular vistas from atop Cadillac Mountain. Bar Harbor and the Porcupine Islands are in the mid-ground, with Frenchman Bay and Gouldsboro extending into the distance.

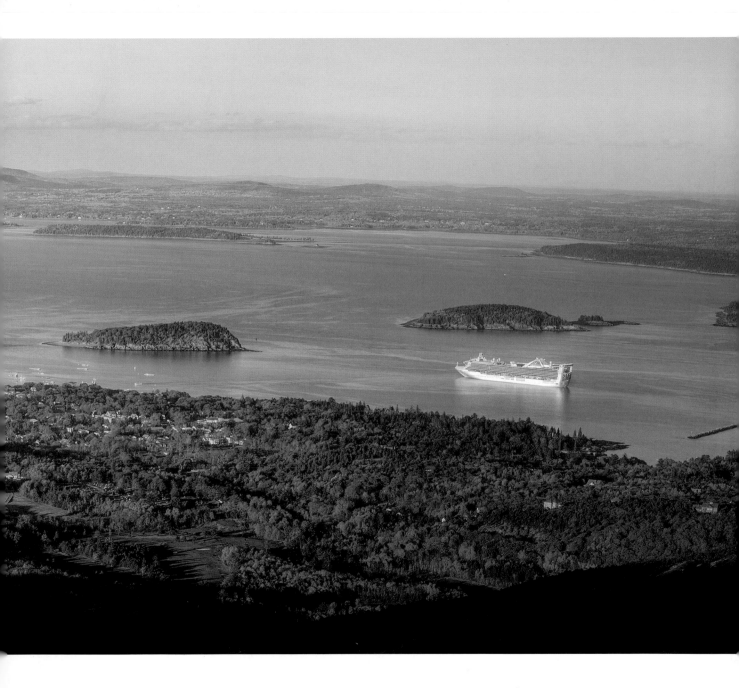

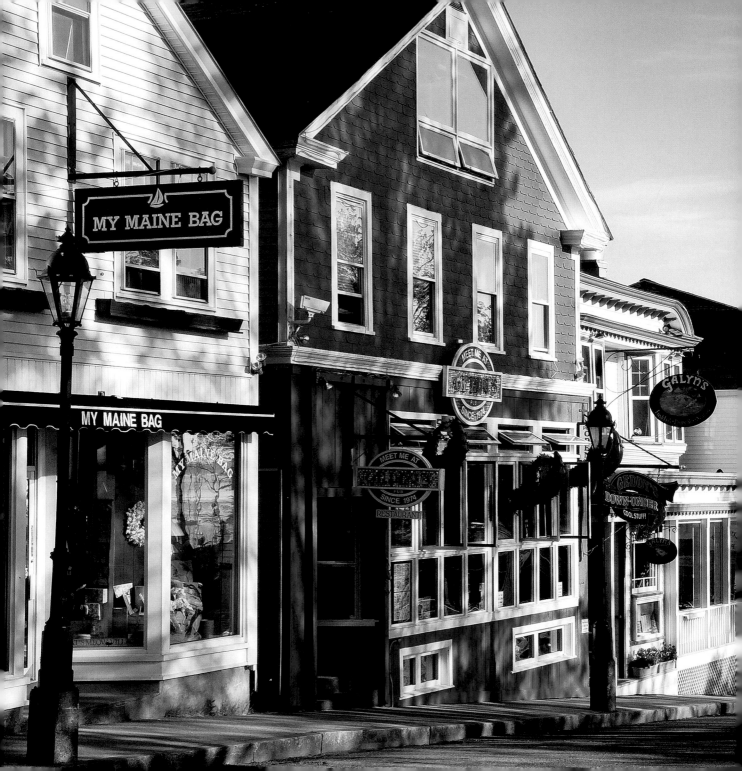

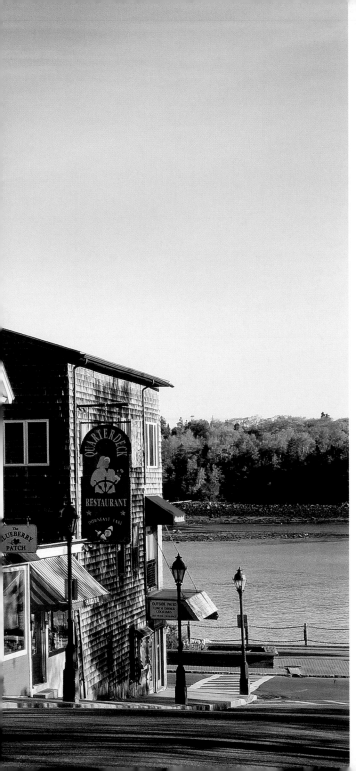

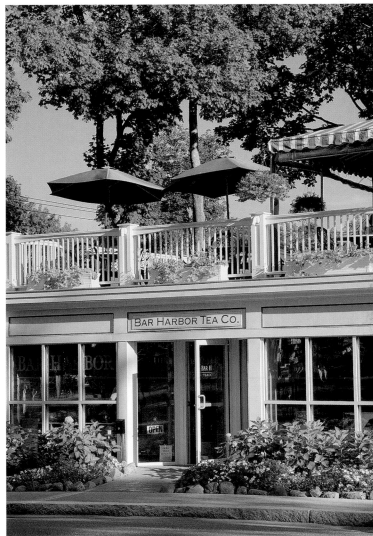

Left: In Bar Harbor all the roads seem to lead either to the sea—as with Main Street, seen here—or to Acadia National Park. **Above:** It's often difficult to get a good cup of tea while traveling—not so in Bar Harbor.

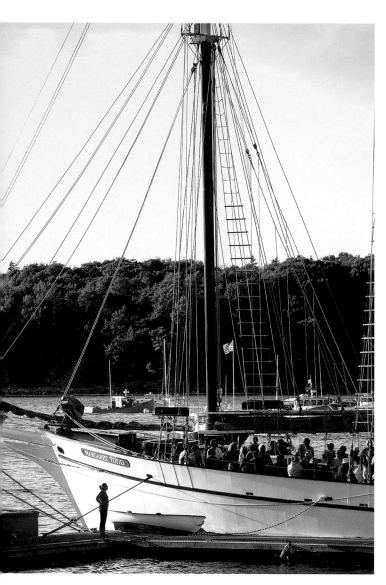

Though styled after traditional wooden schooners, the 151-foot *Margaret Todd* is a steel-hulled vessel designed by her owner, Captain Steven Pagels, and launched in 1998 from St. Augustine, Florida. She is difficult to miss in the harbor and is the only large windjammer in Bar Harbor to take visitors on daily cruises.

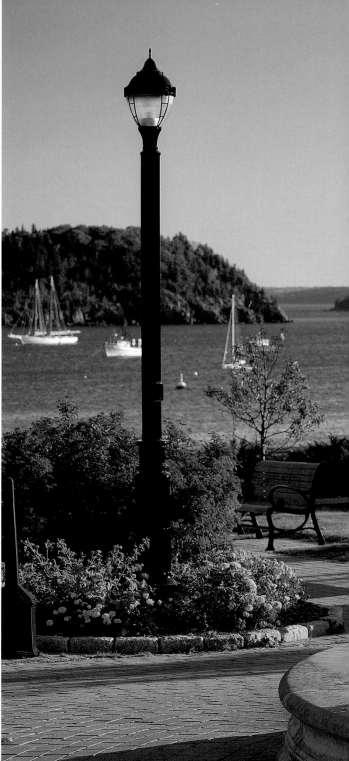

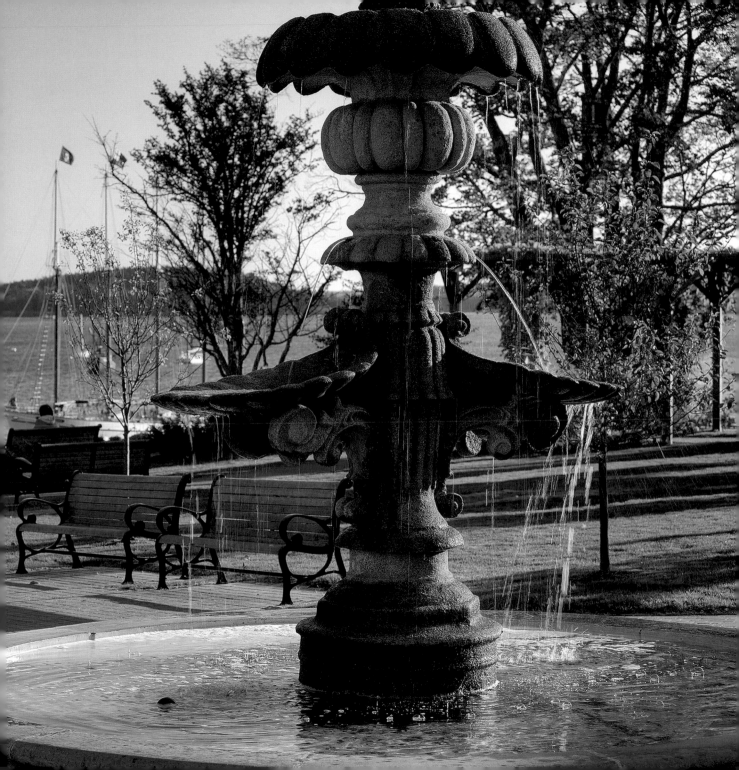

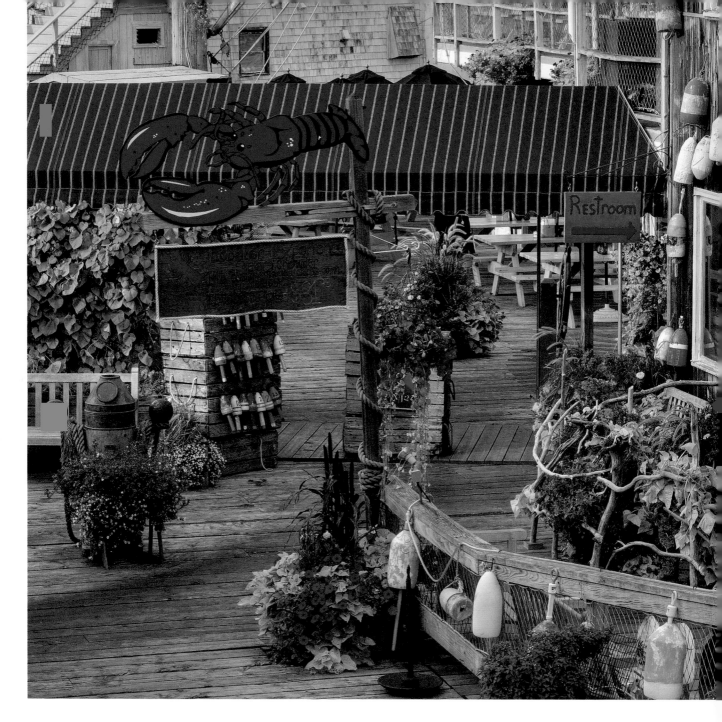

Left: Stewman's is Bar Harbor's only authentic waterfront lobster pound. They will even ship fresh lobsters anywhere in the U.S. and Canada. **Above:** The Fair Trade Winds shop on Firefly Lane offers a variety of unique and quirky items, all fair-trade certified, so visitors can shop guilt-free.

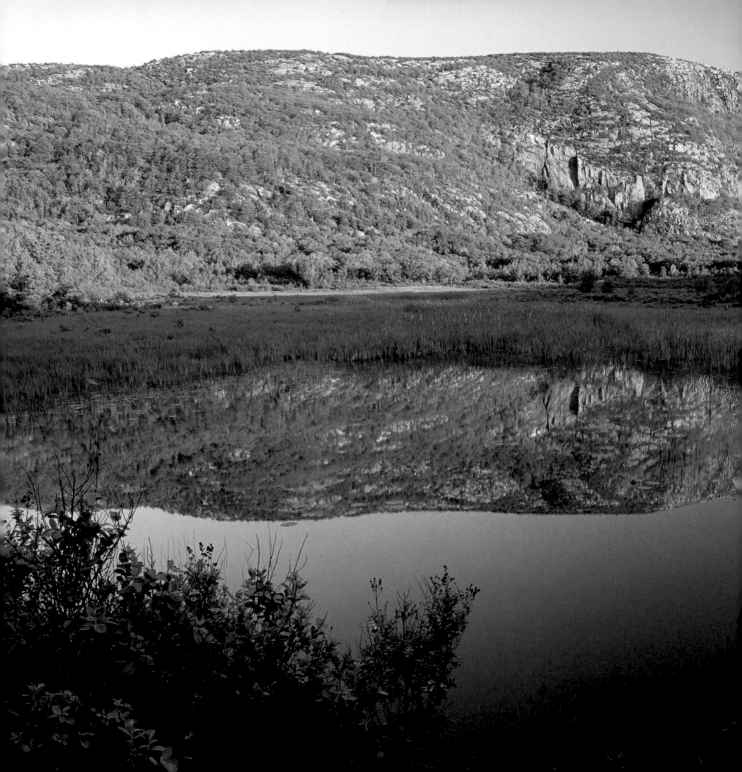

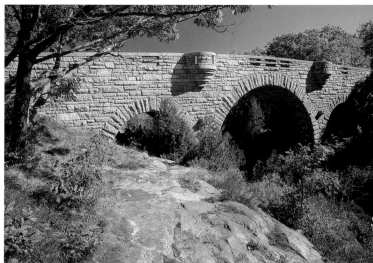

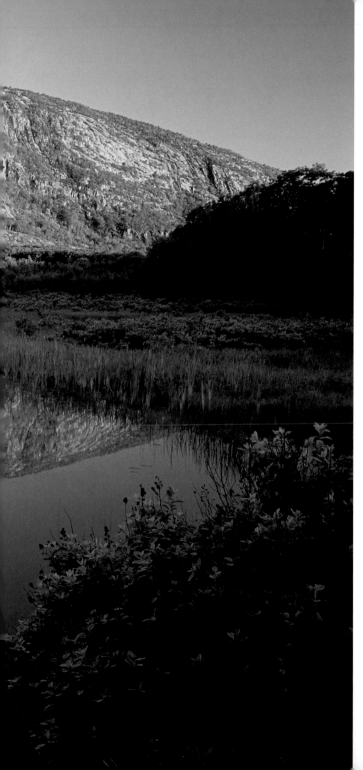

Left: Seen here at dawn from Schooner Head Road, 1,058-foot Champlain Mountain can be hiked via two different trails. **Above:** The impressive Duck Brook Bridge is the largest in the carriage road system of Acadia National Park. It features balconies with views out to Frenchman Bay and to the park woods, and a stone stairway down to the brook.

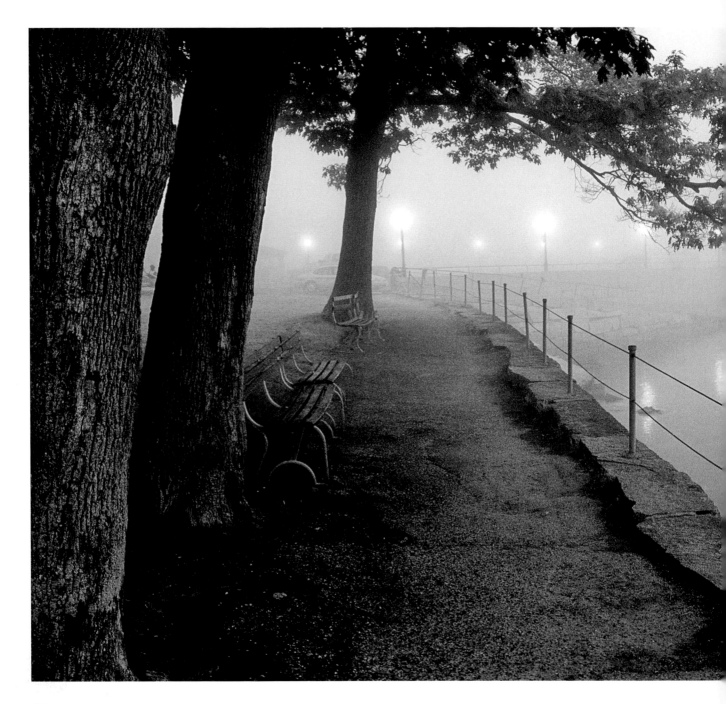

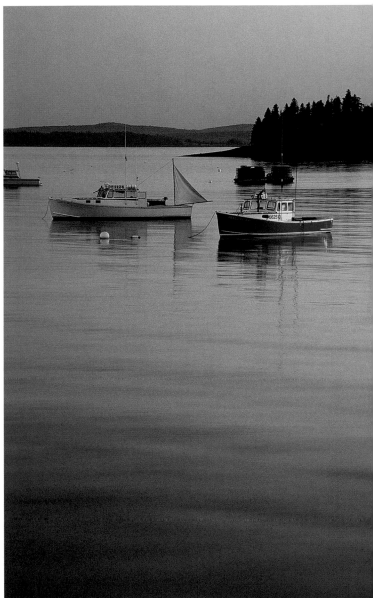

Left: The right combination of evening light and fog makes the Shore Path eerily beautiful. **Above:** Lobster boats are as ubiquitous in Bar Harbor as anywhere else on the Maine coast.

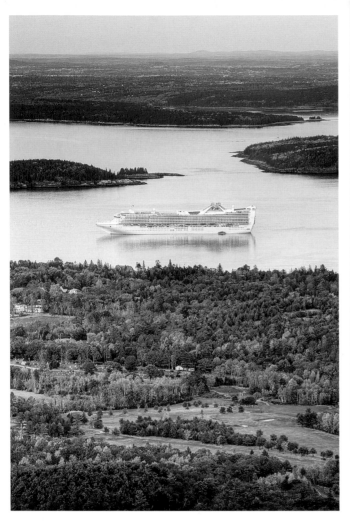

Ever since the first rusticators began coming to Bar Harbor in the mid-nineteenth century, the area's major charm has been the ocean—and it still is. Thousands of visitors arrive each year on cruise ships, and sailing, sea kayaking, and whale watching are immensely popular. Though the *Margaret Todd* (right) strikes a powerful pose at sunrise, harbor cruises don't start until later in the morning. Sunset cruises, however, are available.

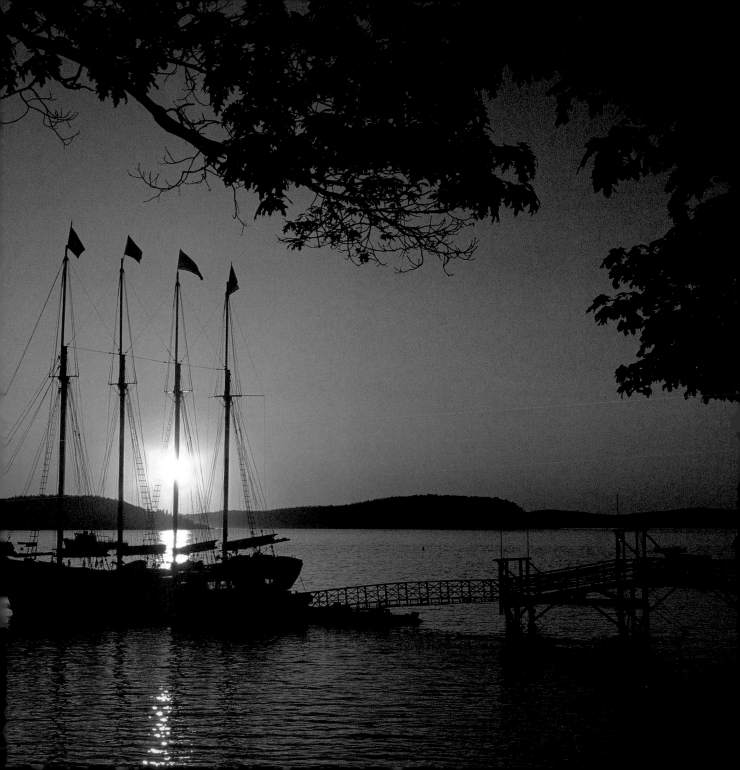

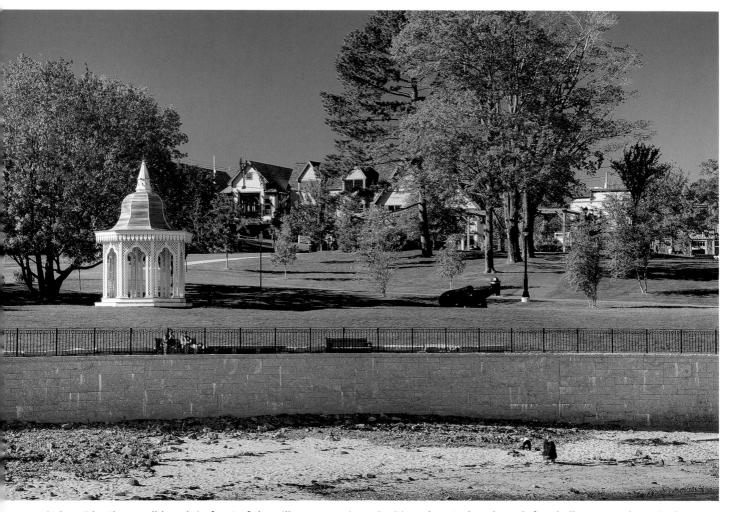

At low tide, the small beach in front of the village green is an inviting place to beachcomb for shells or sea glass. And on warm spring days, the green itself is an inviting place to rest and enjoy the scenery.

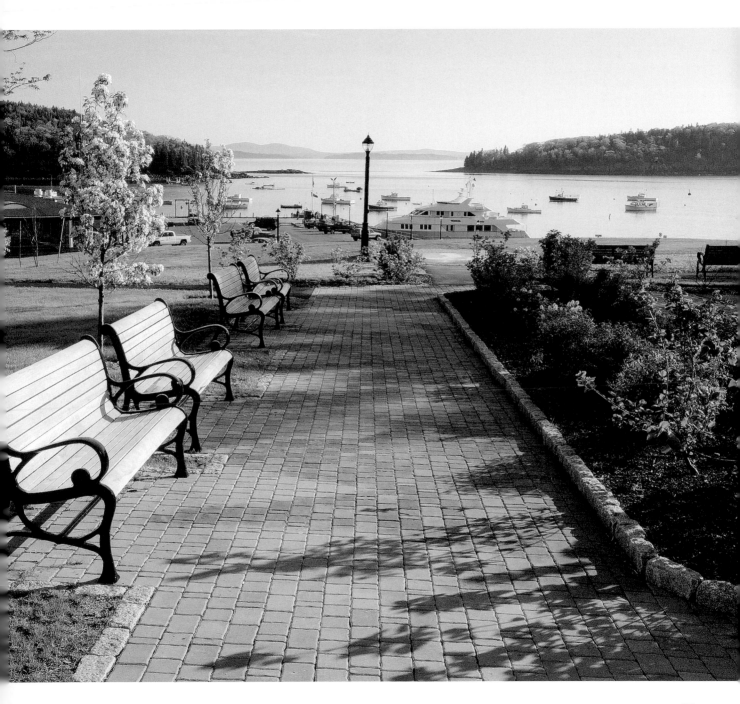

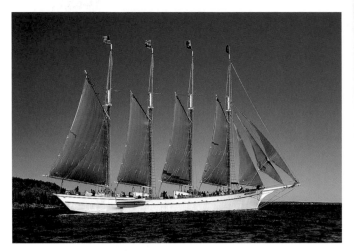

Above: With her distinctive four-mast configuration, the *Margaret Todd,* fully rigged, carries 4,800 square feet of sail. **Right:** Thunder Hole is one of the most popular spots in Acadia National Park. It is a very small inlet in the rock, and when a wave of the right size rolls in, a deep sound like distant thunder can be heard. The sound is caused by the wave colliding with air and forcing it out a narrow opening. Spray may roar as high as 40 feet into the air.

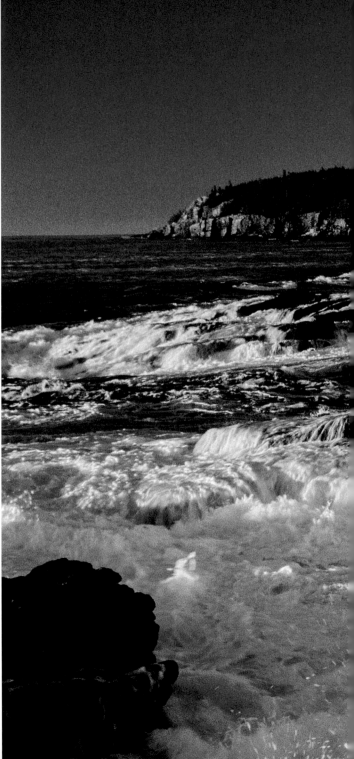

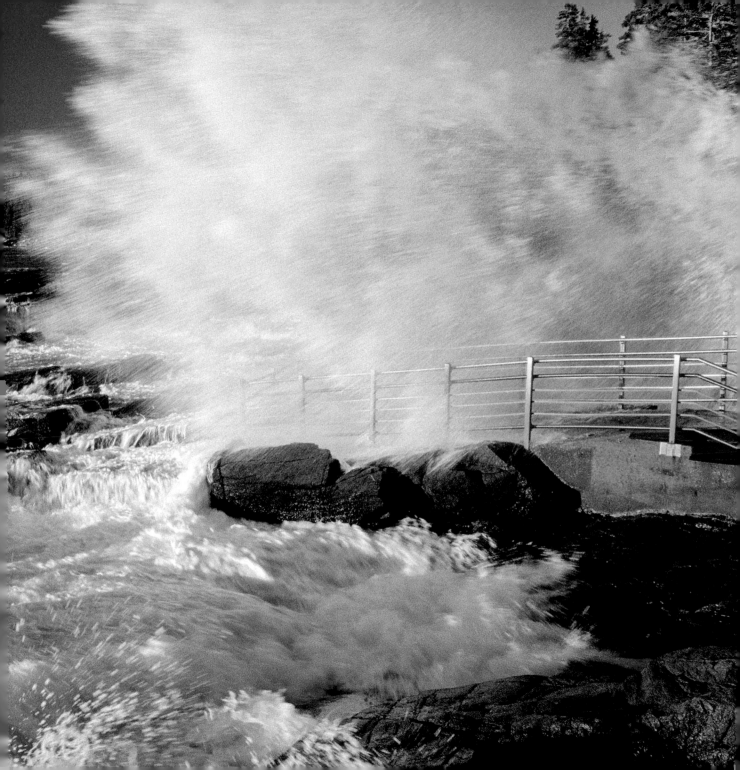

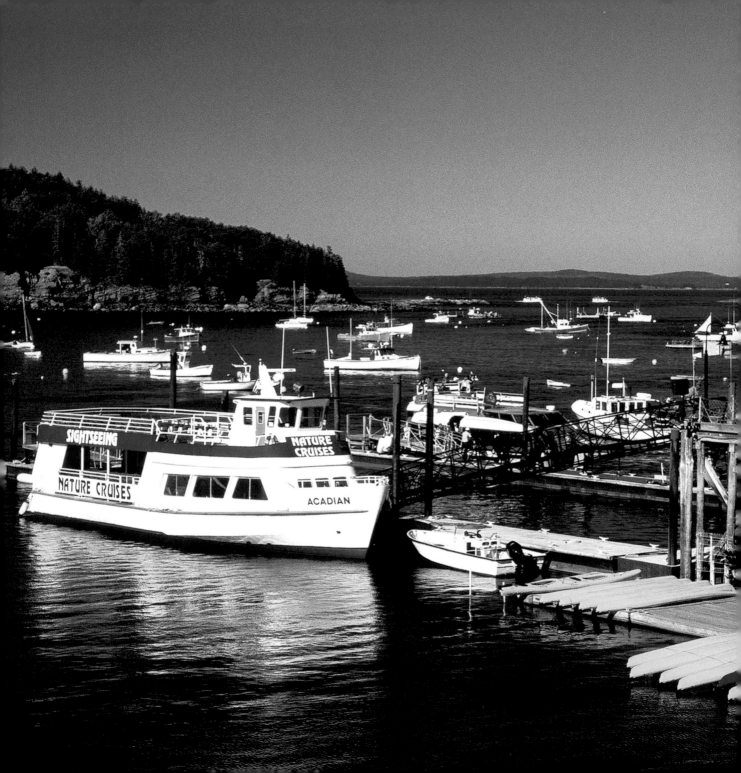

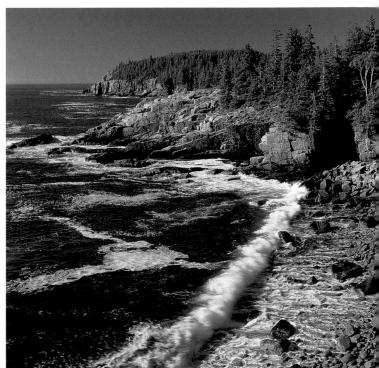

Left: Wildlife cruises, including whale and puffin watches, and guided sea kayaking tours are favorite activities in Bar Harbor. **Above:** At a height of 110 feet, Acadia National Park's Otter Cliffs (seen here from above Monument Cove) form one of the highest Atlantic coastal headlands in North America.

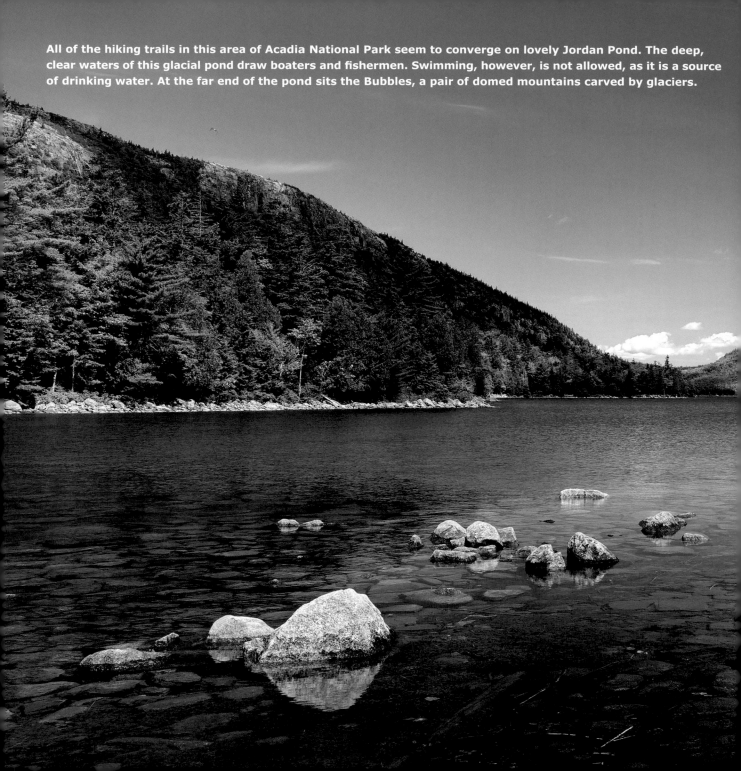

All of the hiking trails in this area of Acadia National Park seem to converge on lovely Jordan Pond. The deep, clear waters of this glacial pond draw boaters and fishermen. Swimming, however, is not allowed, as it is a source of drinking water. At the far end of the pond sits the Bubbles, a pair of domed mountains carved by glaciers.

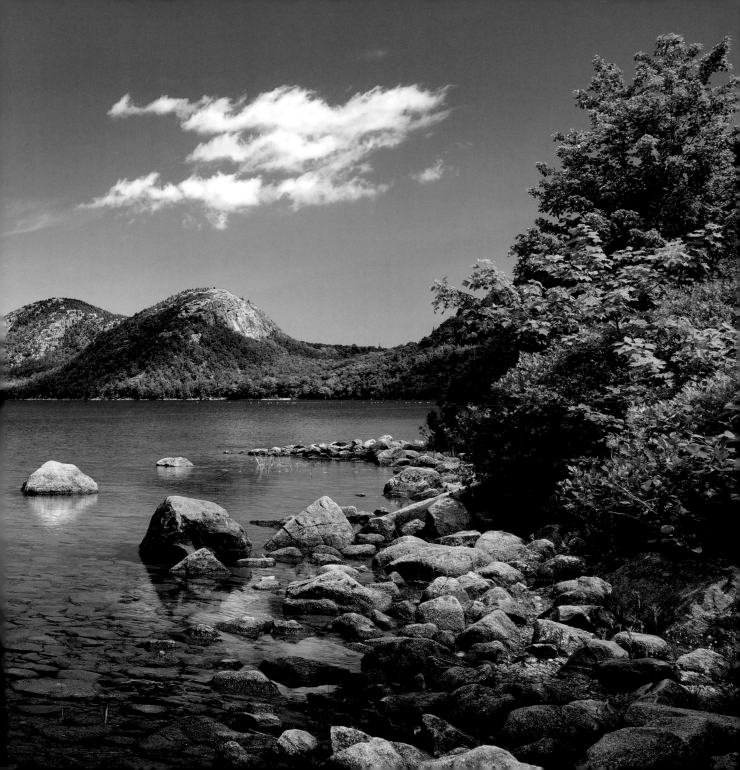

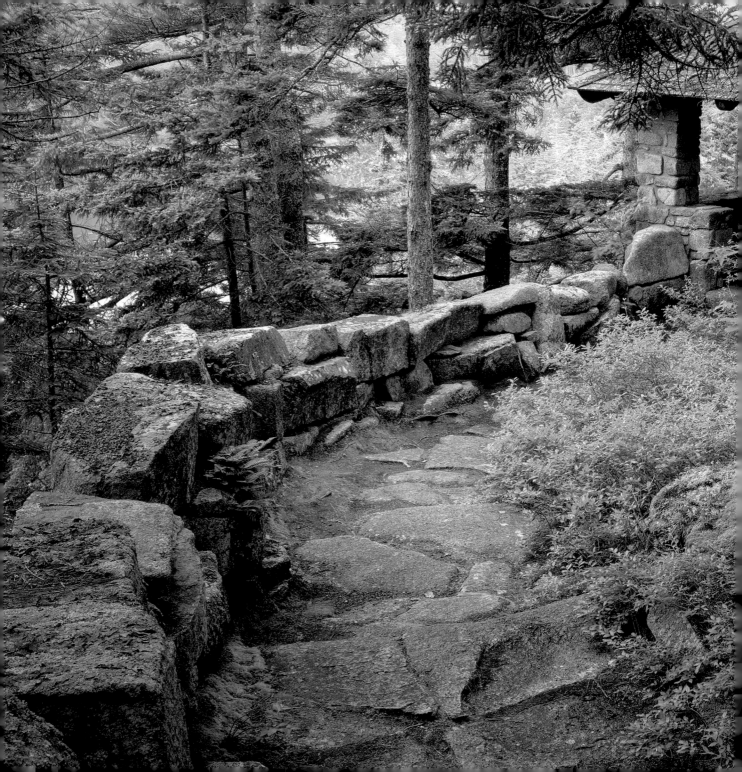

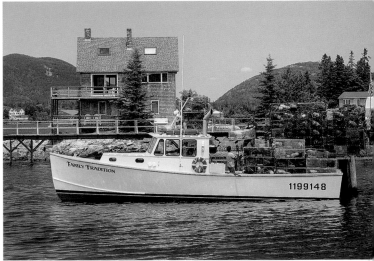

Left: Not far from the Asticou Azalea Gardens in Northeast Harbor, the Asticou Terraces ascend to Thuya Lodge and Garden, providing scenic overlooks and rest spots along the way. The terraces were a labor of love by renowned landscape architect Joseph Henry Curtis, and it shows. Curtis was a long-time summer resident of the area and chose to give Asticou Terraces, Thuya Lodge, and Thuya Garden to the public for quiet reflection and enjoyment. **Above:** Bass Harbor is a perfect example of a quaint little fishing village on what is called the "quiet" or "back" side of Mount Desert Island.

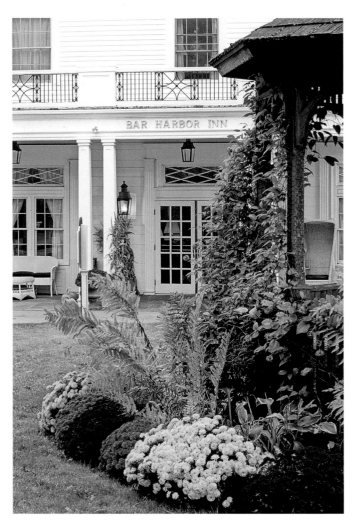

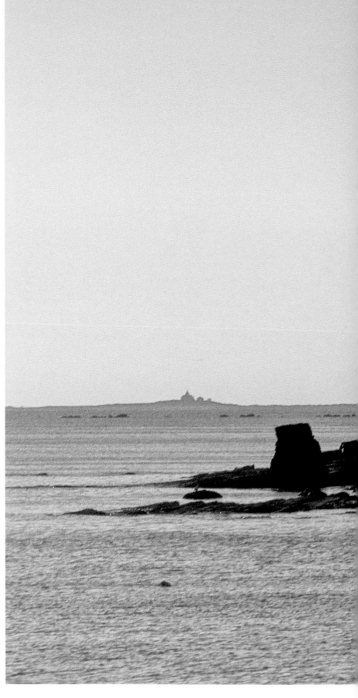

Above: Perhaps the most recognizable structure in town, the Bar Harbor Inn is a world-class resort. **Right:** The rising sun illuminates Egg Rock Light in the distance at the entrance to Frenchman Bay.

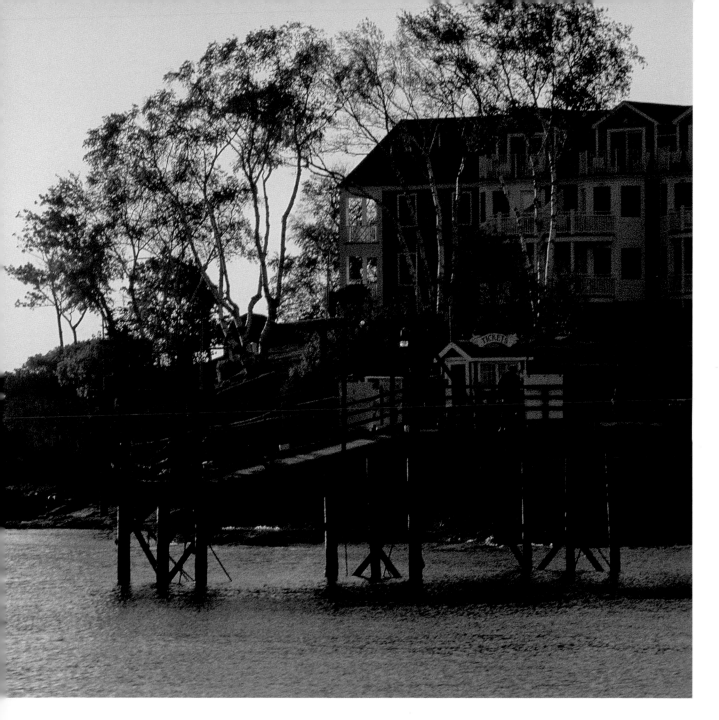

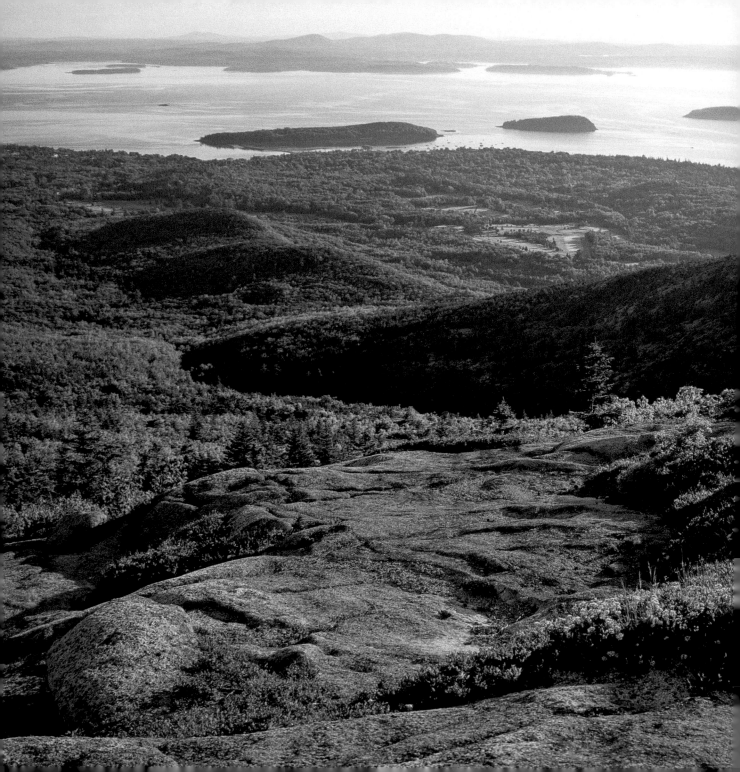

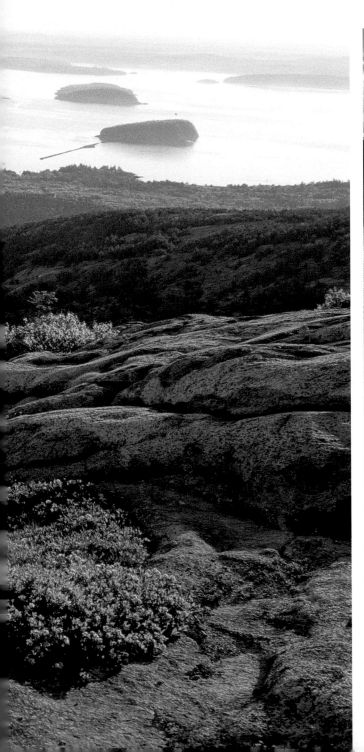

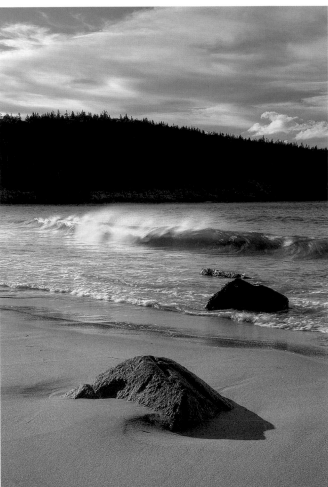

Left: Early summer atop Cadillac Mountain and the blueberry bushes are in bloom. The Maine coast has thousands of islands and the five nearest Bar Harbor are Bar Island (farthest left) and the Porcupines: from left, Sheep Porcupine, Burnt Porcupine, Long Porcupine, and Bald Porcupine. The small islet just to the right of Burnt Porcupine is called Rum Key. **Above:** Composed largely of ground shell fragments, Sand Beach in Acadia National Park is a beautiful rarity along this part of the Maine coast. Though it is gorgeous and inviting, swimmers beware: the water temperature rarely exceeds 55° in the summer.

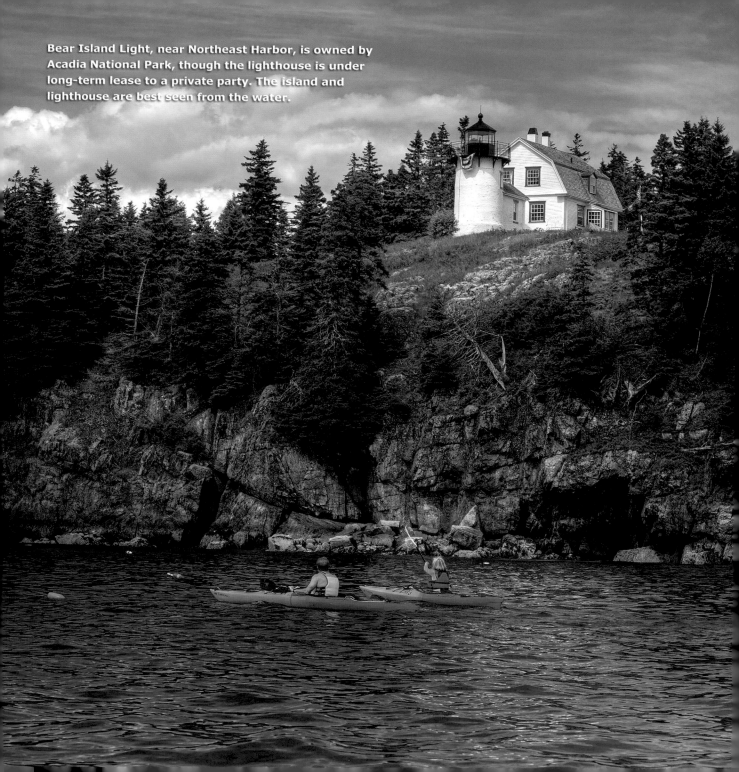

Bear Island Light, near Northeast Harbor, is owned by Acadia National Park, though the lighthouse is under long-term lease to a private party. The island and lighthouse are best seen from the water.